Graffiti
A Children's Guide to the Origins of Hip Hop

Lamont Clark

Published by 70 West Press

Copyright 2013 Lamont Clark

Foreword

This book was created from and for my love of Hip Hop, with my sons, nephew, and niece in mind.

Table of Contents

Introduction	4
Graffiti in Ancient Times	5
Modern Graffiti	9
Graffiti in Books, Movies, and Magazines	18
Graffiti Moves On	23
About the Author	26
Other Books by Lamont Clark	27

Introduction

The word "graffiti" comes from the word *"graffito"* which means 'scribbling' in Italian. Many people think that graffiti is just drawing symbols, images, or words on private or public surfaces without permission, but it is much more than that.

The originators of the art form here in the United States didn't call what they did "graffiti", they simply called it "writing". The name "graffiti" was coined in 1971 by The New York Times newspaper when they did an article on a writer names Taki 183.

Because of its origins, Graffiti has been connected with the other elements of Hip Hop, but it really wasn't until 1981 when the movie *Wild Style* was created that the final linking between MCing, DJing, B-Boying, and Graffiti were firmly established.

This isn't to say that they weren't already connected. Growing up in New York during the 1970s many of the same kids who DJed, MCed, or B-Boyed, may have also been Writers (we will call them Graffiti Artists). So the connection was always there. It's just that DJing, MCing, and B-Boying was considered performances, but Writing was considered a crime.

This is the story of the origins of 'writing', better known as Graffiti.

Graffiti in Ancient Times

Before the invention of paper, there was what many call "rock art", "cave art", or "cave drawings". These drawings were done for not only for decoration, but to communicate messages to people.

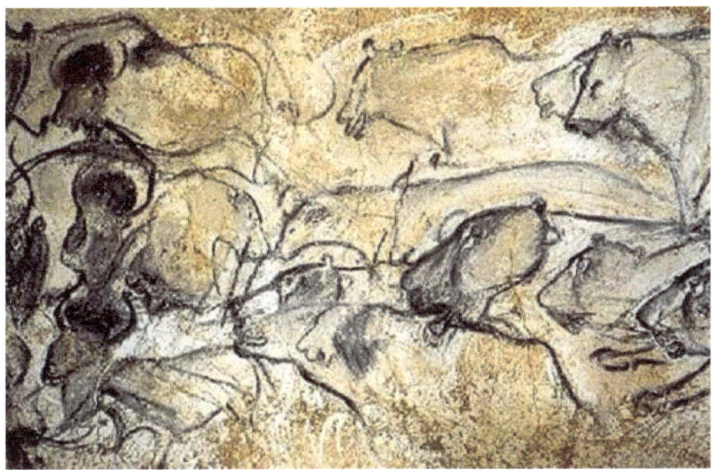
Chauvet Cave

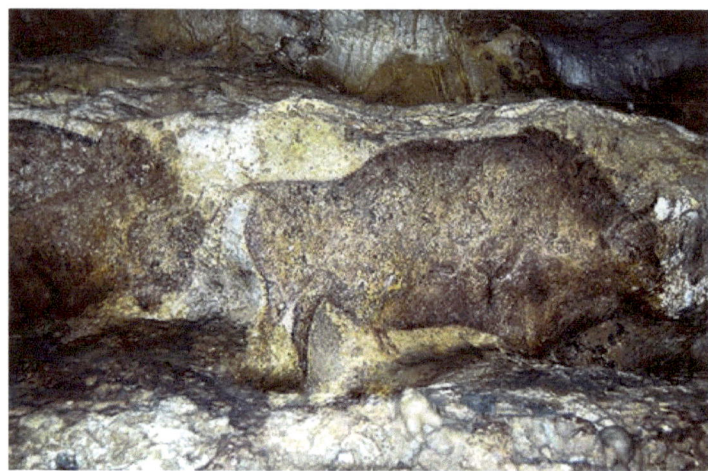
Font-de-Gaume

Many of the word's ancient cultures have been known to have had graffiti in their cities. Archaeologists have found graffiti on the walls of Pompeii, and ancient city of the Roman Empire.

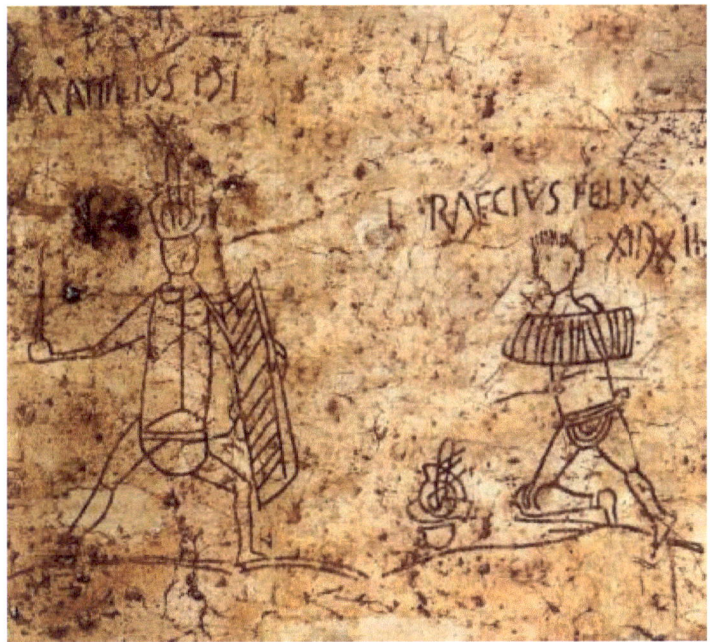
Roman Graffiti

Although the ancient Egyptians invented papyrus (which was a thin, paper-like material), their hieroglyph was one of the most intricate writings and drawings that could be found on walls.

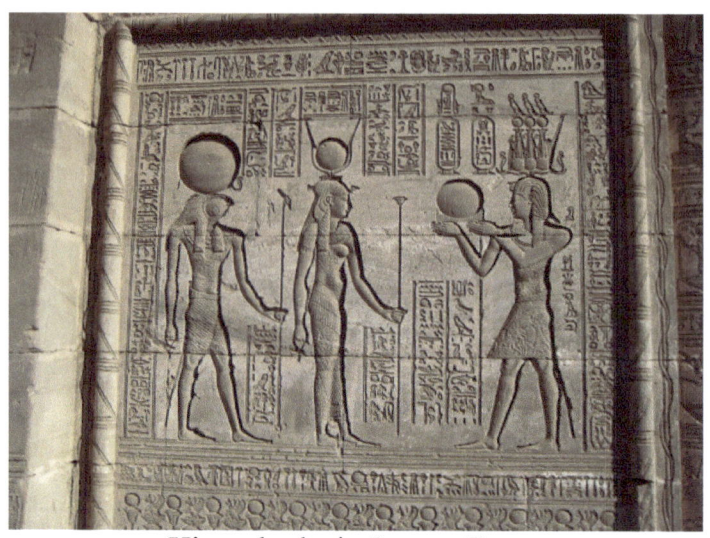
Hieroglyphs in Luxor, Egypt

Modern Graffiti

Most people associate modern graffiti with New York City, because some time during the late 1960s street gangs in New York would mark their territory by writing it on walls in their neighborhoods, but the first people not affiliated with a gang to actually begin "tagging" (writing your name) on walls and other places were Darryl 'CornBread' McCray and 'Cool Earl' who lived in Philadelphia, Pennsylvania.

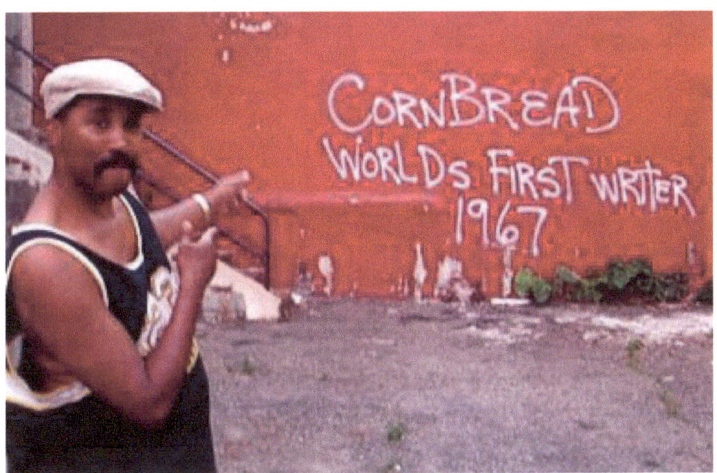

CornBread

After CornBread and Cool Earl began writing their name all across Philadelphia, scrawled their names all over the city, a guy who called himself "TOPCAT 126", also from Philadelphia, moved to New York around 1968 and began tagging. Around this same time "Julio 204" was also

tagging, and it became more and more popular in New York.

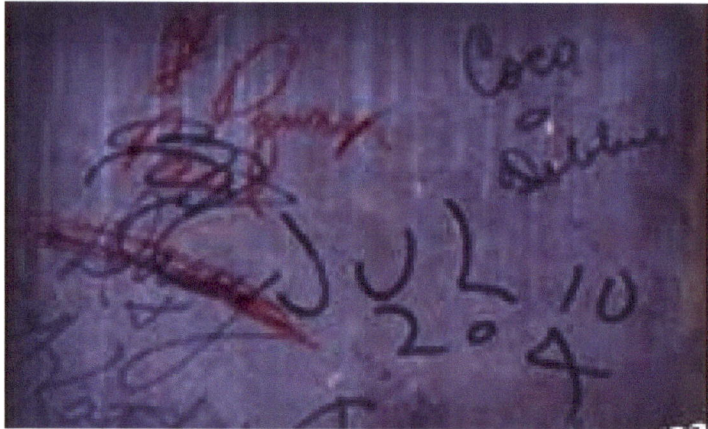
Julio 204

Tagging became so popular in New York, that the newspaper The New York Times wrote an article about a graffiti artist named TAKI 183. After that article, graffiti became even more popular, and graffiti artists began to try to outdo each other. Because there were now so many people writing, people began figuring out different ways to set themselves apart. They would use different types of calligraphy or script, as well as put different designs on their name to make their tag unique.

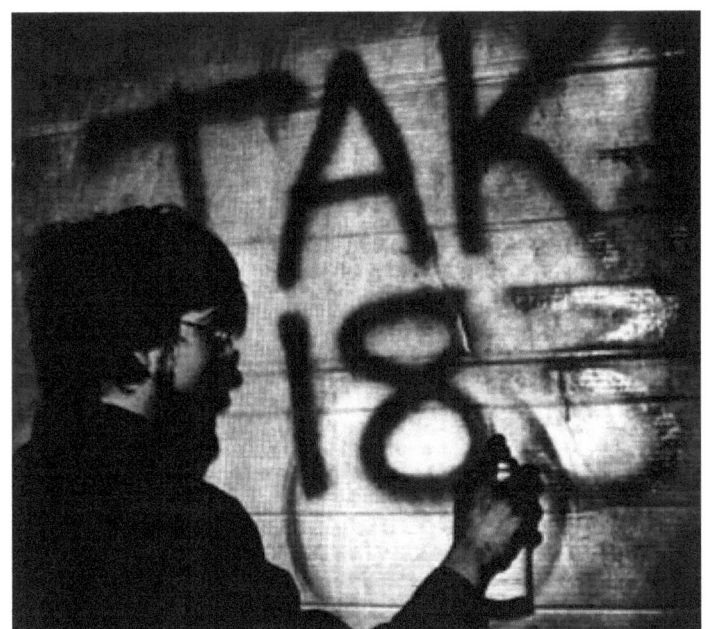
Taki 183

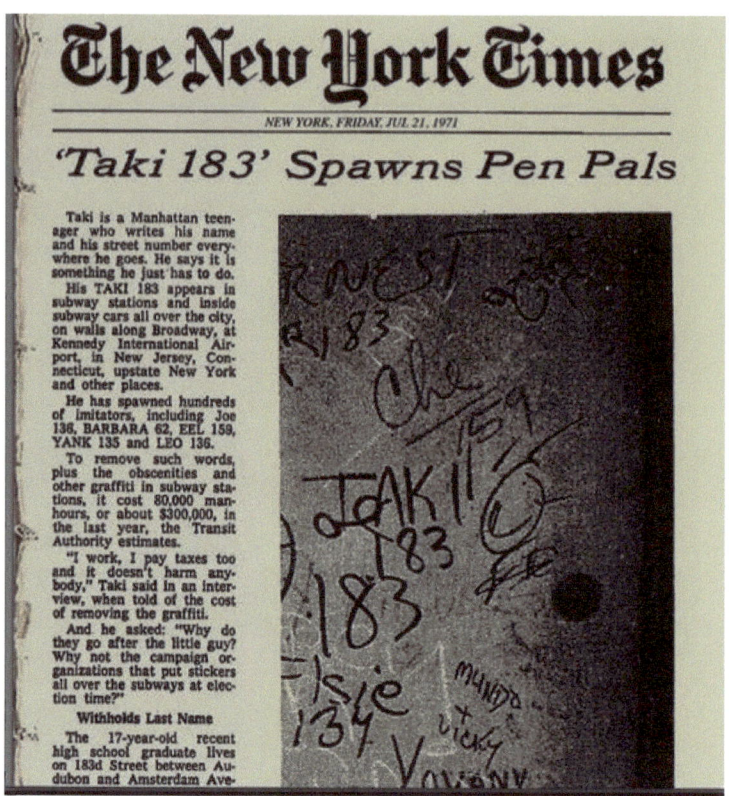
New York Time Article

At this time graffiti artists were mainly "tagging" around town. They would try to get as many "hits" (writing their signature in different places) as they could. The people who had the most hits across the city became known as "Kings". In New York you could also be "All City" which meant that your name was written in each of the five boroughs of New York City (Bronx, Brooklyn, Manhattan, Queens, and Staten Island). Then came "bombing", where they would blanket a park bench, a wall, or a subway car with their name.

After bombing graffiti artists started doing "pieces", short for masterpieces, which was a really big art piece. Many

graffiti artists began doing their 'pieces' on New York City subway cars because the subway moved all throughout the city, and people would see their art wherever the subway traveled. Many people credit "Super Kool 223" and "WAP "as being the first people to actually do pieces on subway cars.

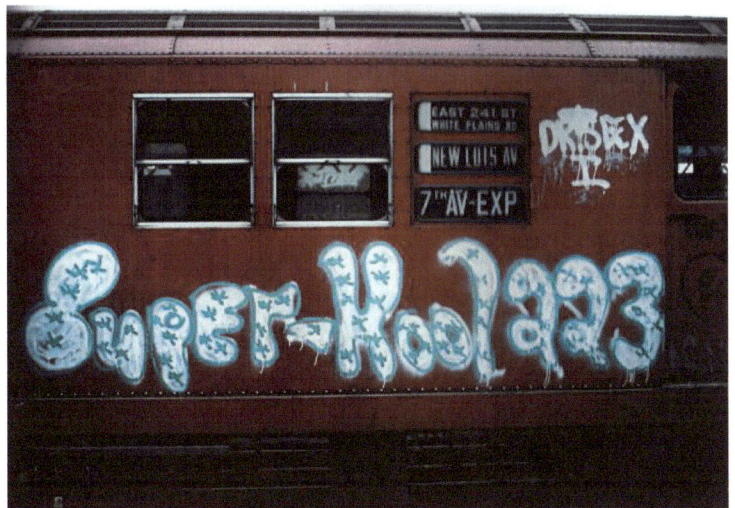

Super Kool 223

Artists were creating styles of writing that were used by other artists in their pieces. Artists such as Phase 2 is credited for creating 'Bubble' lettering, Tracy 168 is credited with creating 'Wild Style', and Case 2 is credited with creating 'Computer' lettering.

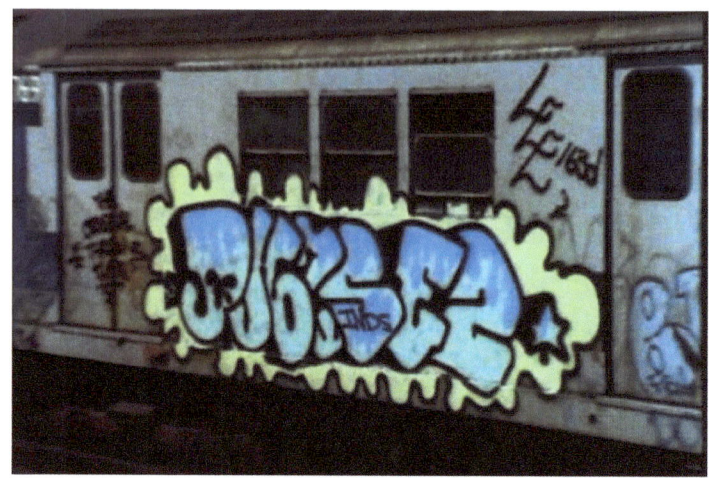
Phase 2

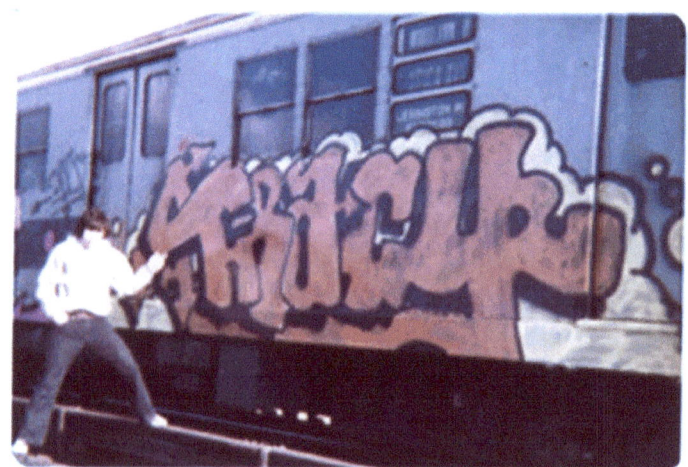
Tracy 168

Case 2

Artists such as Cliff 159 and Blade One took pieces to a higher level by adding the elements of cartoon characters to their works.

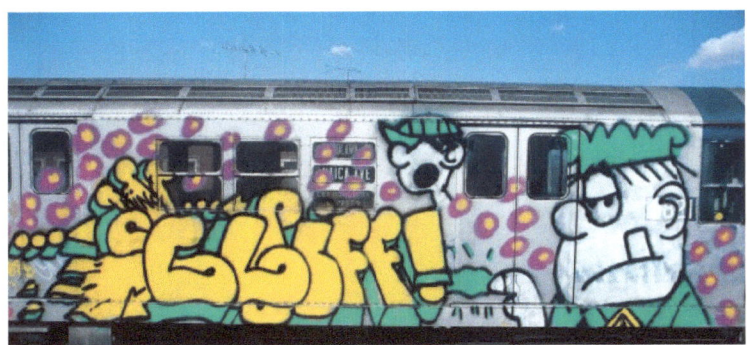

Cliff 159

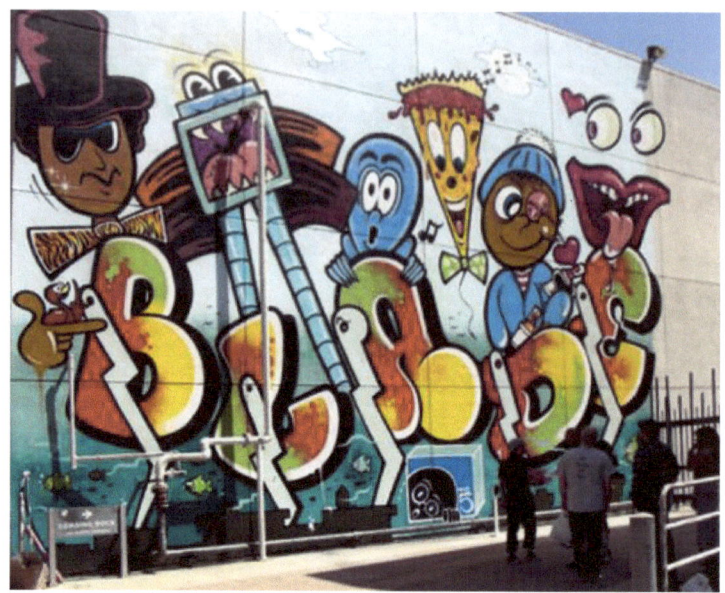

BLADE

 Although graffiti was mostly street art, Hugo Martinez thought that it could be seen as a more legitimate art form. In 1972 he created the United Graffiti Artists. Hugo saw this as an alternative to the art world, and this allowed the best graffiti artists across New York City an opportunity to showcase their work in art galleries and even sell their work. In the following photo (from 1973) you will see the following artists: From left, first row: COCO 144 and Hugo Martinez; second row: Rican 619, LEE 163, and Nova 1; third row: Rick 2, Ray-B 954, Cano 1, SJK 171, Snake 1, and Stay-High 149; fourth row (standing): Stitch I, Phase 2, Charmin 65, Bug 170.

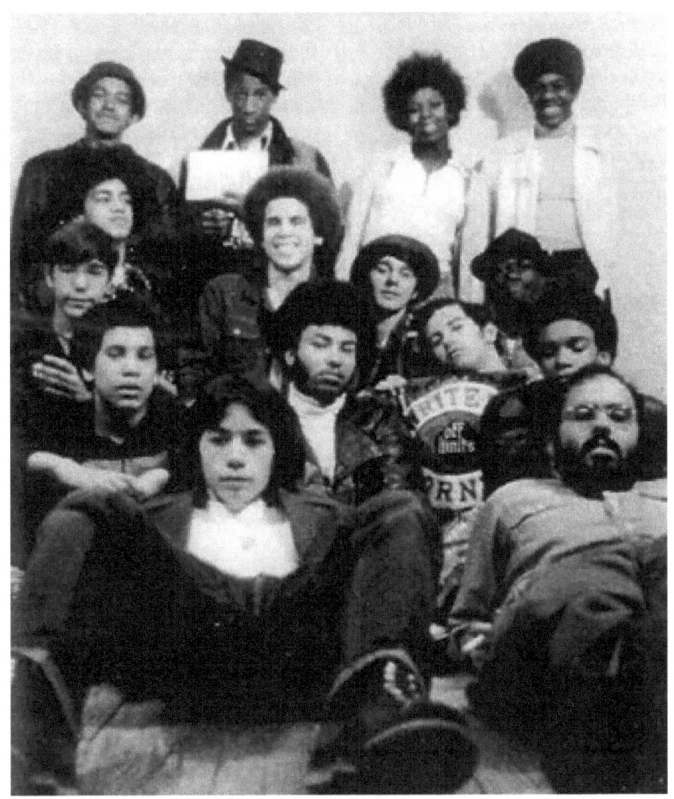
United Graffiti Artists

Graffiti in Books, Movies, and Magazines

Artists such as BLADE, Tracy 168, and Futura 2000, LEE (Lee Quinones), and Freddy (Fab 5 Freddy) were not only popular because their work could be seen across the city on subways and in galleries, but books were being written, and by 1980 movies were being created.

Fab 5 Freddy

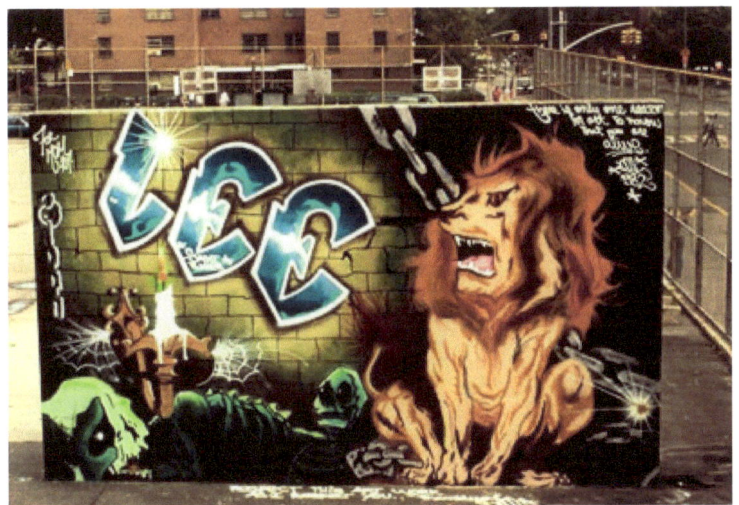

Lee Quinones

Futura 2000

In 1971 Norman Mailer wrote the first book about graffiti called *The Faith of Graffiti*. Ten years later Fab 5 Freddy convinced Charlie Ahearn to make a movie called *Wild Style*. The movie *Wild Style* is important not only because it

was considered the first 'Hip Hop' movie, but it was the key piece that tied all of the elements of Hip Hop together. *Wild Style* featured Graffiti artists, MCs, DJs, and B-Boys all in one movie. By 1984 photographer and artist David Schmidlapp published the first magazine on graffiti called *International Graffiti Times*.

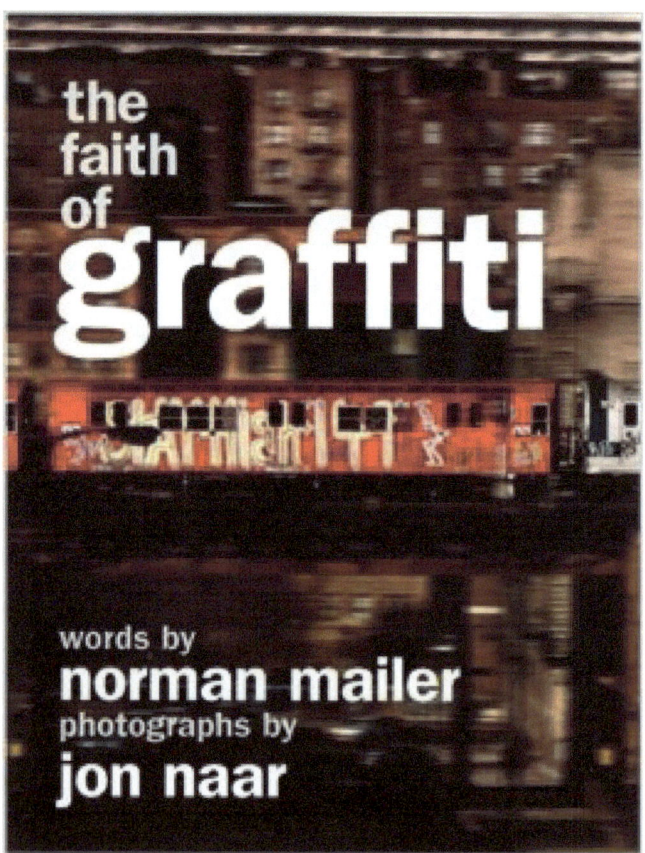

The Faith of Graffiti

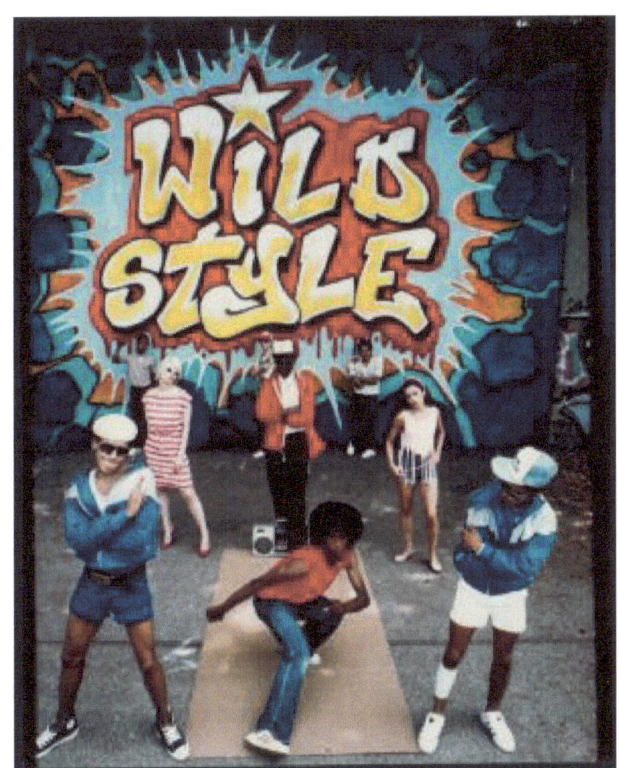
Wild Style

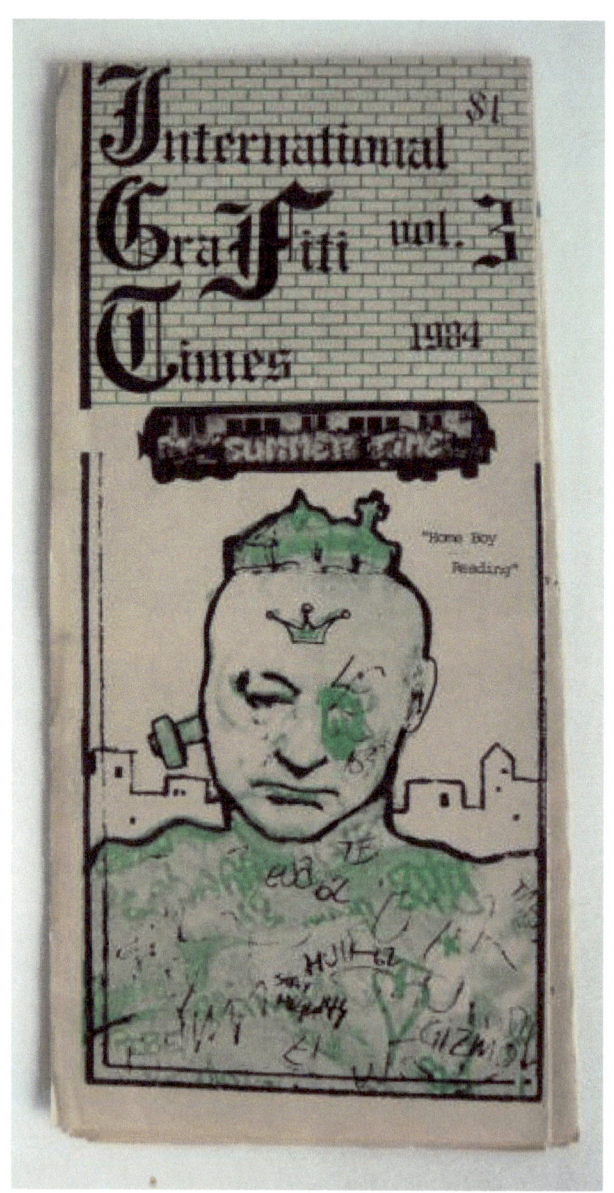

International Graffiti Times

Graffiti Moves On

Graffiti was definitely and art form, but everyone did not view it that way. Many people in New York viewed it as vandalism and as a symbol of just how bad New York City was during the 1970s. While some people could appreciate the art of graffiti on walls and subway trains, other people hated it because they had to ride the subway cars and couldn't see out the windows, or just got fed up with graffiti being written on their property. This led to graffiti task forces being created and even Anti-Graffiti laws.

But just like the other aspects of Hip Hop culture, graffiti had become popular world-wide. The films *Style Wars* (by Tony Silver) and Wild Style, as well as the book *Subway Art* by Henry Chalfant and Martha Cooper helped Graffiti become popular in Europe.

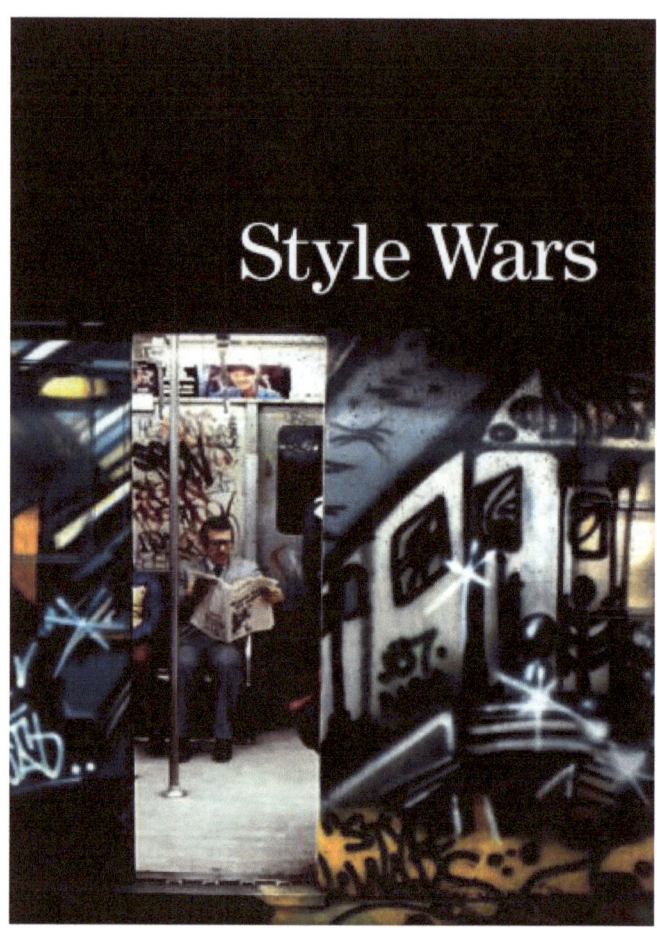

Style Wars

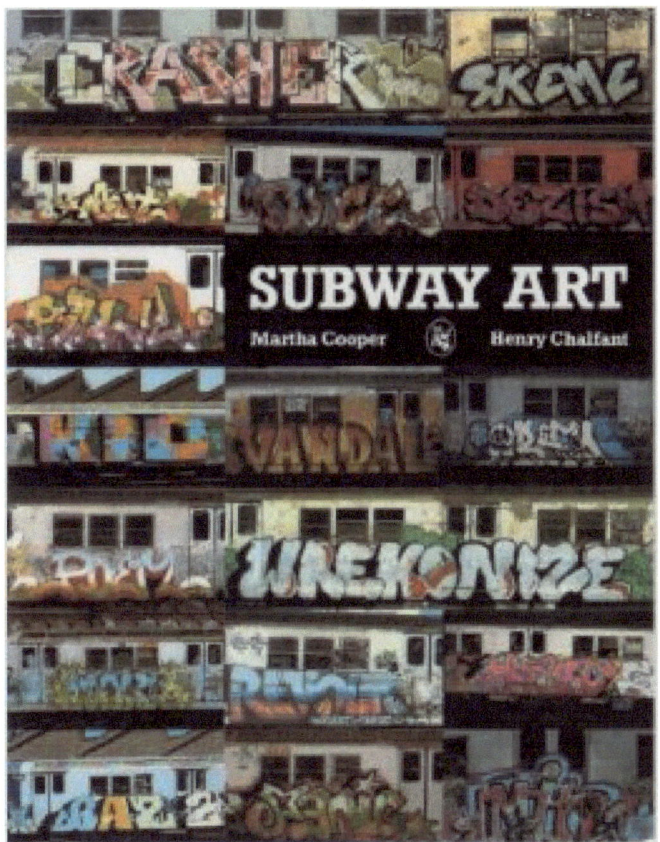
Subway Art

Today graffiti is an accepted part of youth culture. While there are still laws against it, you are likely to see pieces on walls, stores, and other places where the artist was actually paid to do the work. Graffiti can also be seen in art galleries across the world and can also be found on many websites online. What was once considered vandalism by many is now an accepted art form

About the Author

Lamont Clark was born and raised in Mount Vernon., New York. He is a graduate of the University of Maryland at College Park (Smith Business School) and earned his MBA at the University of Maryland University College.

A man of many interests and talents, in addition to writing, Lamont has over 20 years of experience in the entertainment industry as a musician, record producer, on-air radio personality, actor, and television producer and director. Lamont is a multiple award winning producer and director for his television shows.

Lamont also has over ten years of experience teaching and training both adults and children. Lamont is married with two sons.

Connect With Me:

Follow me on Twitter: http://twitter.com/lamontclark
Friend me on Instagram: http://instagram.com/lamontclark
Subscribe to my blog: http://lamontclark.com
Favorite me at Smashwords: https://www.smashwords.com/profile/view/70westpress

Discover other Titles by Lamont Clark

Books and eBooks:

The Five Elements of Hip Hop: DJs
The Five Elements of Hip Hop: B-Boys
The Five Elements of Hip Hop: Graffiti
Cheesecake Delights! 77 Gourmet Cheesecake Recipes
Wonderful World of Wings! 85 Mouth Watering Wing Recipes
A Coffee Lover's Dream! 88 Great Tasting Coffee Recipes
Cookie Cravings! 101 Divine Cookie Recipes
Popcorn Love! 101 Exquisite Gourmet Popcorn Recipes
Chocolate Heaven! 500 Scrumptious Chocolate Recipes
Yummy! Yummy! 101 Fun Children's Recipes
Family History! How to Turn Your Genealogy Into a Lasting Legacy
An Independent Musician's Guide To: How to Make $100K in the Music Business Without a Record Deal
An Independent Landlord's Guide: How to Start, Run, and Profit from Rooming Houses

www.ingramcontent.com/pod-product-compliance
Lightning Source LLC
Chambersburg PA
CBHW040915180526
45159CB00010BA/3072